I Love Colors!

When I created my original collection of Teacup Kittens paintings, I made sure to make them as colorful as possible. I just love colors! I can't resist the temptation to buy big sets of coloring tools even if I never get around to using all of them. It makes me feel so happy and content just to be surrounded by a lot of different colors.

Here are just a few of my original paintings, done with watercolors and colored pencils. I hope these inspire you! I turned these paintings into black and white line art for this book.

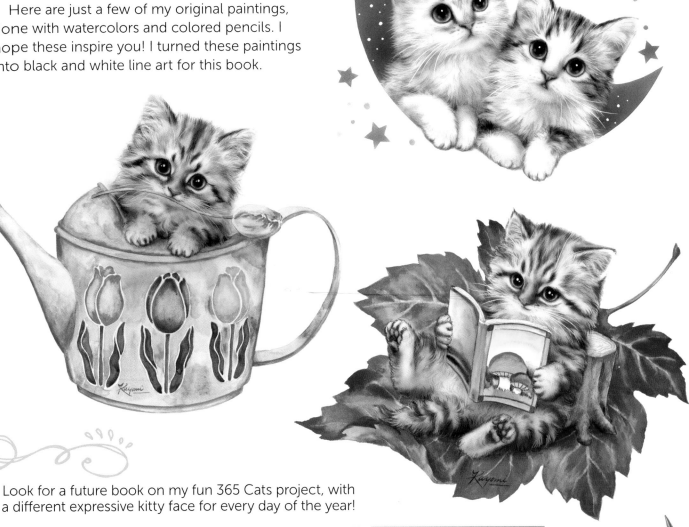

Look for a future book on my fun 365 Cats project, with a different expressive kitty face for every day of the year!

My Art Style

I like coloring with traditional media. My favorite method is a combination of colored pencils and watercolors. Each kitten's eyes are the most important element of the art, so I always start by drawing the eyes with colored pencils. Then, when I'm happy with how the eyes have come out, I paint over them with watercolor. Next, I try to capture the softness and fluffiness of the fur by drawing fine lines with sharpened colored pencils. Then I apply a watercolor wash over the fur and, after it's dry, add some more colored pencil strokes.

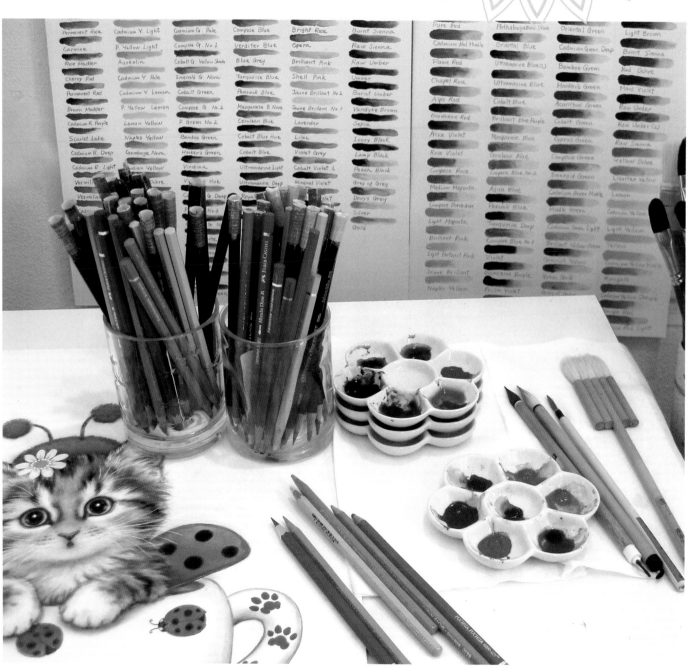

A view of my desk area with my coloring and painting supplies and the original art of the Ladybug teacup kitten.

Let's Color!

Be creative and bold. There are no rules.

Grab your pens, pencils, markers, crayons, pastels, watercolors, or whatever coloring tools you want, and get started. There are no right ways or wrong ways to color. There is only your way! I've been painting all my life without completely understanding color theory. I seem to select colors instinctively rather than based on theory. So don't be intimidated by the thought of learning color theory (though having a color wheel on hand can be useful!). You can be adventurous and experiment with any color you want.

I created the line drawings in this book based on my original paintings. I did my best to re-create the cuteness of the eyes and fluffiness of the fur with detail lines. You might also notice some very light gray shading that I put on the cats as guidelines, but you can choose to ignore them and color any way you want. You can make them look like your cat, color them purple or green, or draw

patterns on them. I hope you will enjoy using your imagination and letting your creativity soar!

Below are two examples that I created using the same kitty design to show you just two possible coloring approaches.

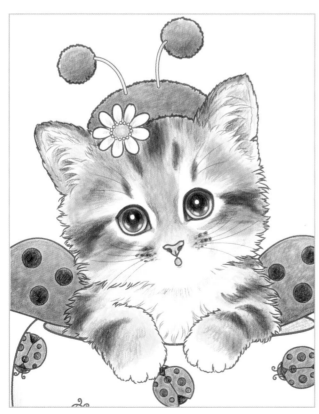

This one is rather realistic, with brown stripes on the kitten and red and black colors for the ladybugs.

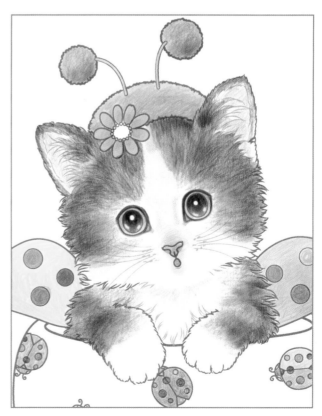

This black-and-white kitten has a very different look when paired with multicolored ladybugs.

Basic Coloring Techniques

Let's explore some basic coloring techniques. I usually work from light to dark, which helps preserve all your colors.

Creating a Shaded Blend

To blend dark and light colors together to create a shaded, 3D effect, first choose three colors: one light, one medium, and one dark. For this example, I used a Derwent Inktense colored pencil, but you can use any brand, and you can also use markers or other tools.

 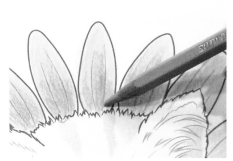 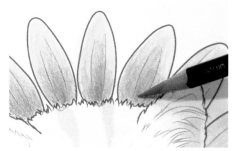

1. Apply the light color all over the area you are coloring.

2. Add the medium color on part of the area you are coloring—don't cover up the entire light-colored area.

3. Finish by adding the darkest color, making sure not to cover up the entire medium-colored area.

Coloring Eyes

Now let's color cat eyes. In this example, I used a range of green colored pencils, plus brown, black, and red, but you can use any colors you want.

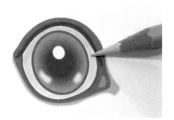 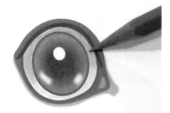 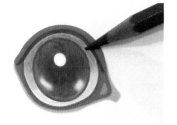 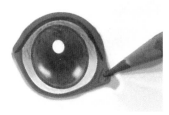

1. Start with a light yellow-green all around the iris.

2. Apply a slightly darker green around the top half of the pupil and in the iris.

3. Add a darker shade of green around the top third of the pupil and in the iris.

4. Add a bit of red or flesh color in the corner of the eye.

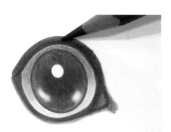 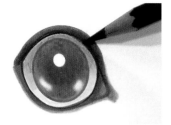

5. Apply light brown all around the eye.

6. Add a dark brown or black line around the top of the eye, like eyeliner.

7. Finish by coloring the pupil a dark brown or black.

Backgrounds

My paintings don't usually have busy backgrounds because I want the kittens to be the focal point without too much distraction. But in this book, you can fill the space creatively, as much or as little as you want! You can draw hearts, stars, stripes, polka dots, or design your own original patterns.

Pastel Backgrounds

If you want a smooth, soft background, try using pastels. They might not be the most commonly used medium for coloring, but I like using them. Here I will show you the method I use to fill a large area with this soft pastel effect.

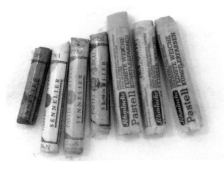

1. Collect some soft pastels. I use Sennelier and Schmincke brands.

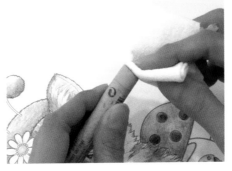

2. Fold a piece of paper towel and rub it on a pastel stick.

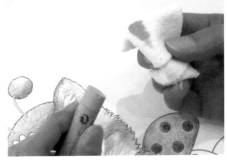

3. Some of the color should come off on the paper towel.

4. Gently apply the color to the paper using a circular motion.

5. Keep going, rubbing the pastel stick as needed to get more color on the paper towel.

6. Repeat the process to spread the color all over the area you want to fill.

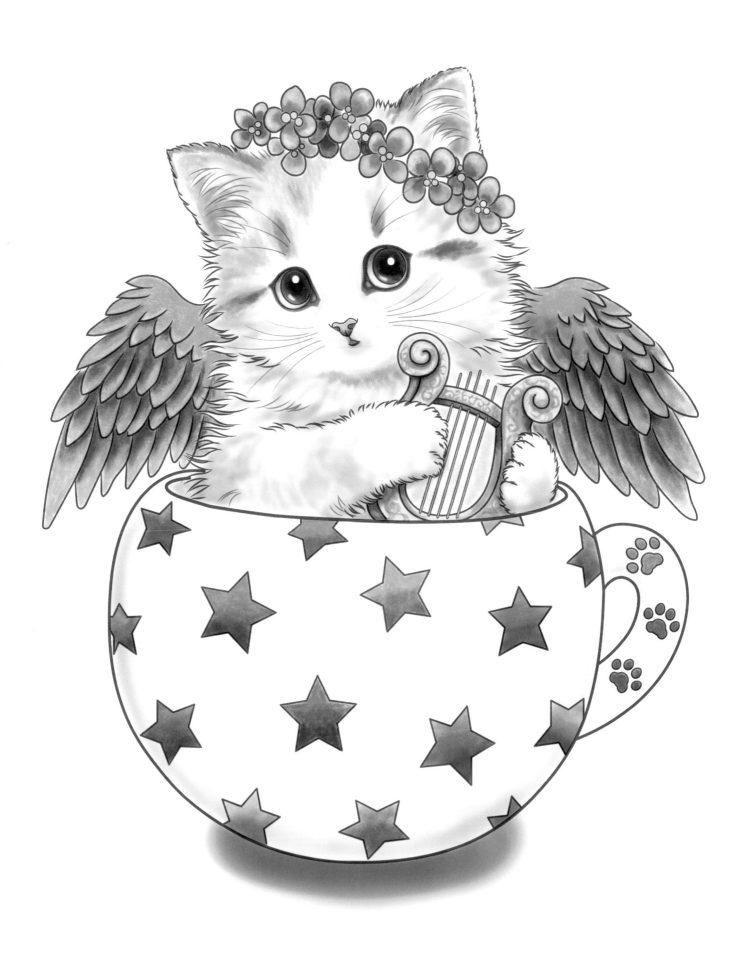

Colored pencils, watercolor. Color by Kayomi Harai.
Angelic Feline, page 33.

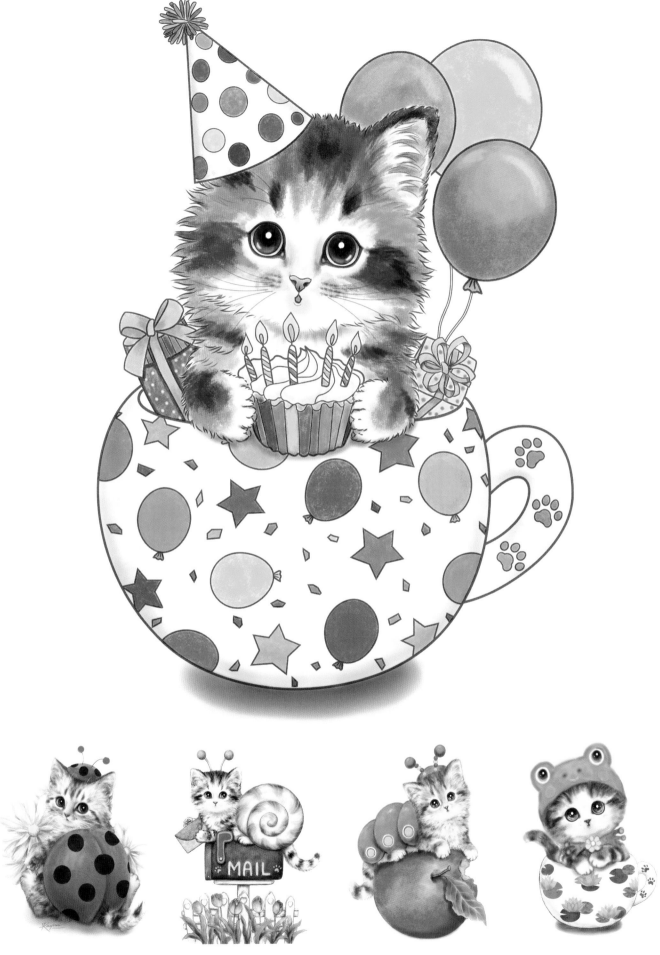

TOP: Make Your Wish, page 65. Colored pencils, watercolor. Color by Kayomi Harai. BOTTOM, left to right: all original watercolor paintings by Kayomi Harai.
Kitty in Red, page 19; Special Delivery, page 51; An Apple and Kitten a Day, page 25; Froggy, page 63.

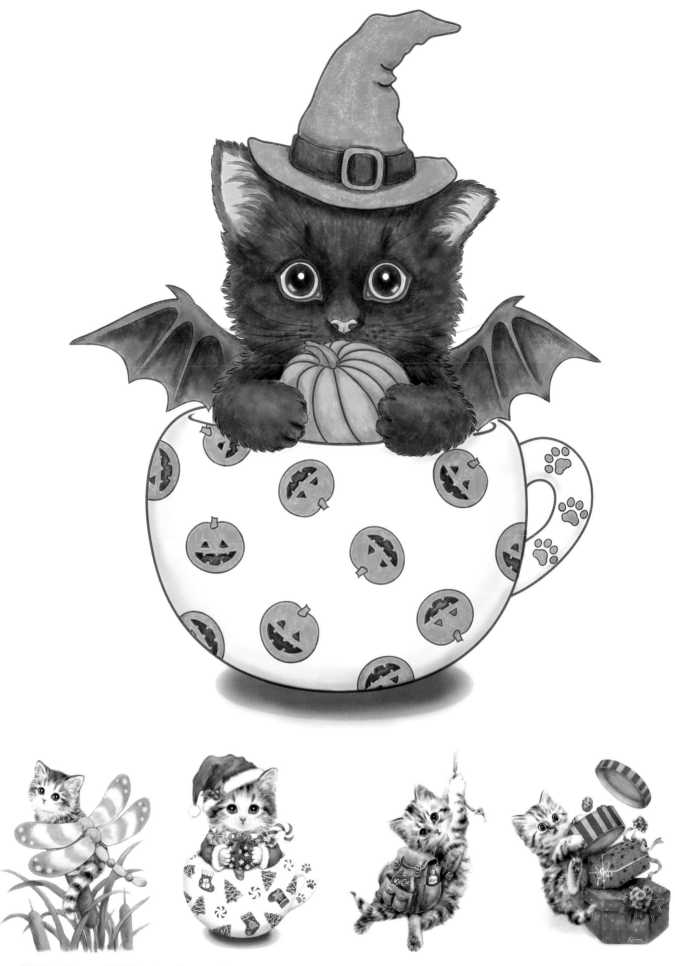

TOP: Boo Kitty, page 35. Colored pencils, watercolor. Color by Kayomi Harai. BOTTOM, left to right: all original watercolor paintings by Kayomi Harai. Winged Wonder, page 29; Christmas Joy, page 43; Adventure!, page 45; Cookie Kitty, page 59.

Summertime Fun, page 67.

Colored pencils, watercolor. Color by Kayomi Harai.
Cup o' Cat, page 39.

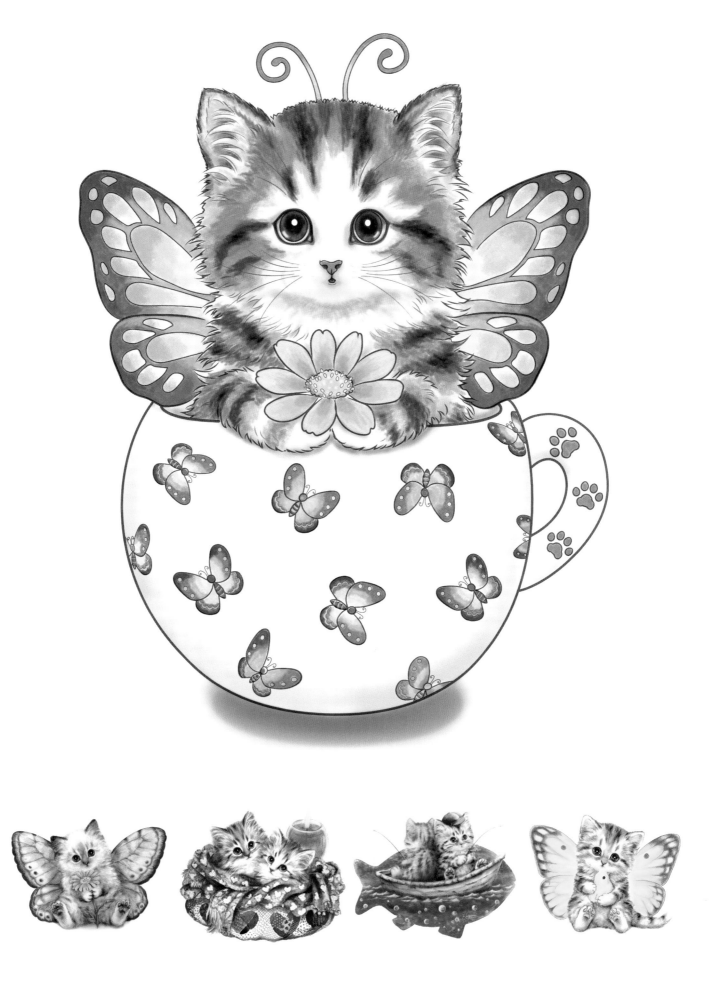

TOP: Cup of Spring, page 73. Colored pencils, watercolor. Color by Kayomi Harai. BOTTOM, left to right: all original watercolor paintings by Kayomi Harai.
A Flower for You, page 49; Cozy Kitties, page 23; Fishing Buddies, page 27; Sweet Hearts, page 57.

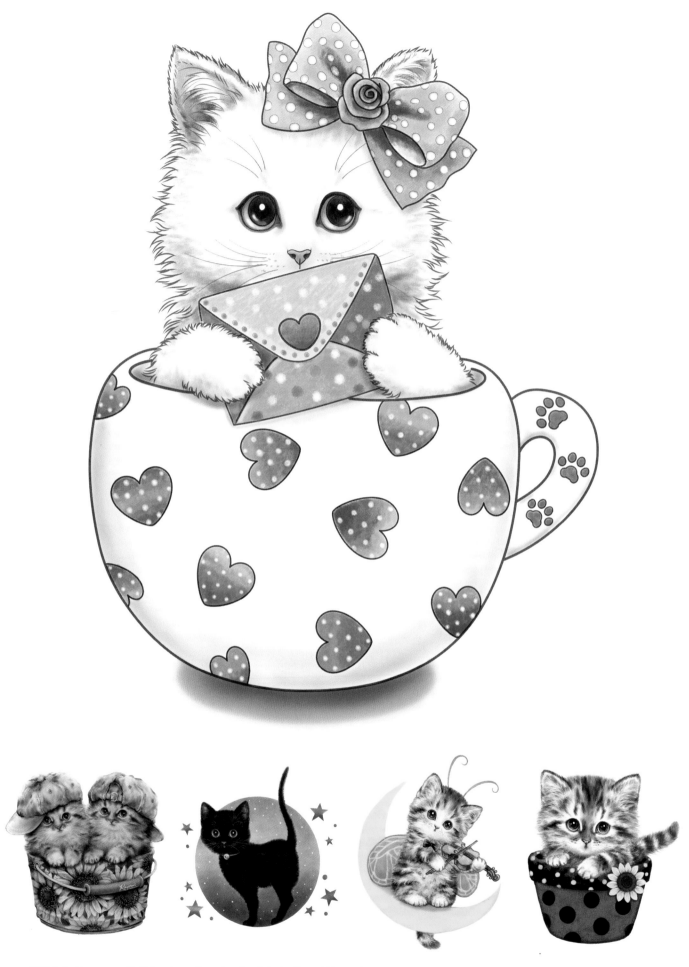

TOP: Full of Love, page 71. Colored pencils, watercolor. Color by Kayomi Harai. BOTTOM, left to right: all original watercolor paintings by Kayomi Harai.

Pals in a Pail, page 47; Full Moon, page 61; Serenade, page 75; Blooming Kitty, page 77.

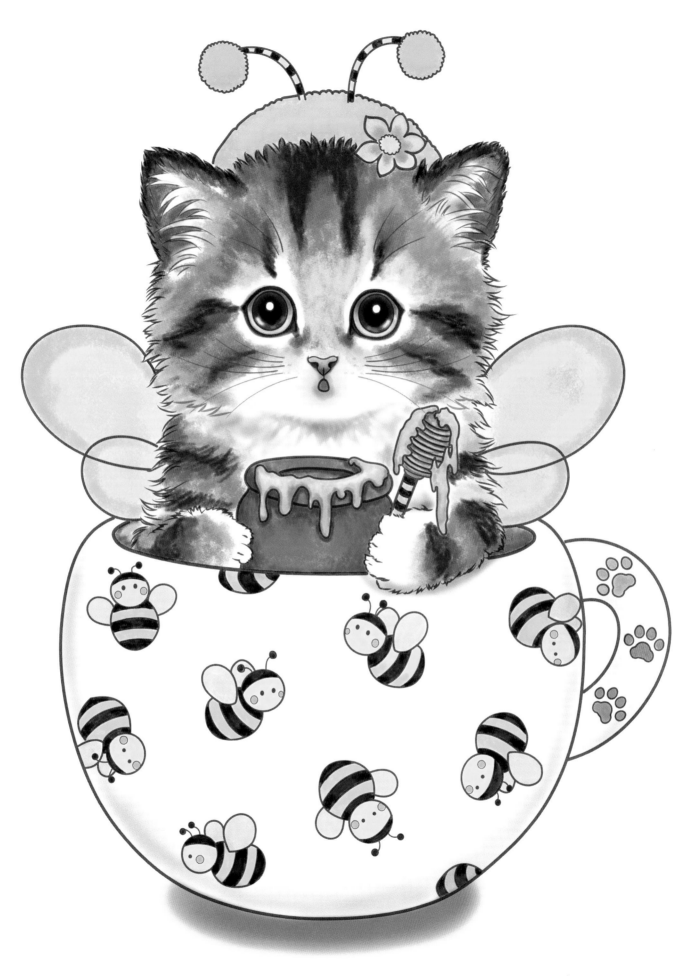

Our Masterpieces

The following pages showcase kitties colored by other artists. I was so excited to see what other colorists did with my artwork!

Colored pencils (Prismacolor). Color by Annie Jump.
Moon Bed, page 79.

Brush pens (Faber-Castell), pastels. Color by Razell Alcazar.
A New Friend, page 37.

Colored pencils. Color by Lynette Parmenter.
Happy Hammock, page 69.

Colored pencils (Faber-Castell). Color by Laura Brumby.
Ladybug, page 21.

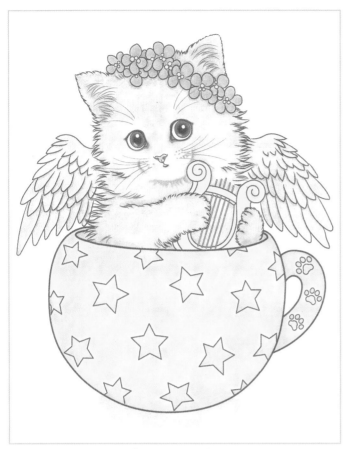

Colored pencils (Faber-Castell). Color by Annie Jump.
Angelic Feline, page 33.

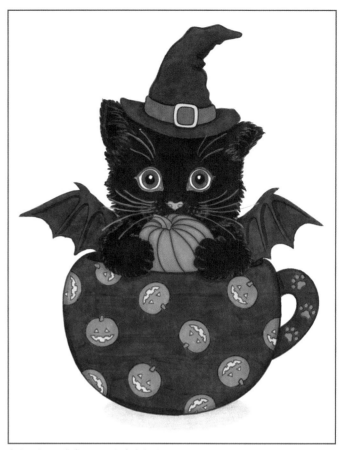

Colored pencils (Prismacolor). Color by Annie Jump.
Boo Kitty, page 35.

Colored pencils. Color by Rachel Simpson.
Cup o' Cat, page 39.

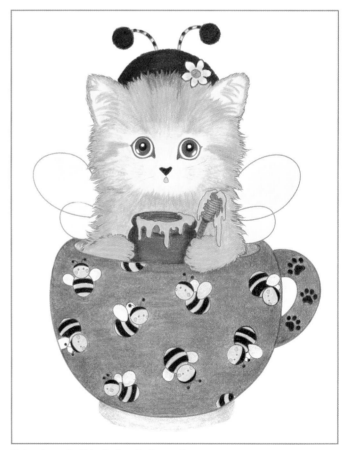

Colored pencils. Color by Lynette Parmenter.
Sweetness, page 41.

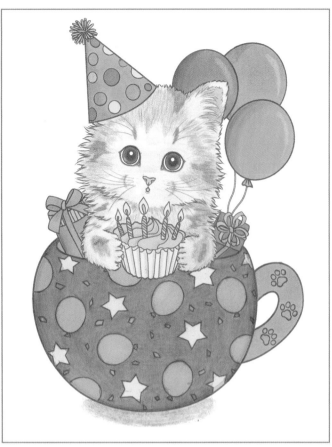

Colored pencils (Faber-Castell), markers (Letraset). Color by Katja Lahti.
Make Your Wish, page 65.

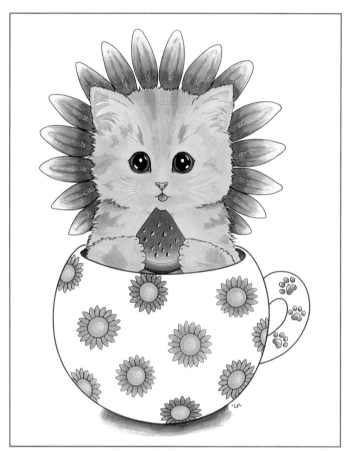

Colored pencils (Prismacolor), markers (Chameleon), gel pens (Sakura).
Color by Llara Pazdan. Summertime Fun, page 67.

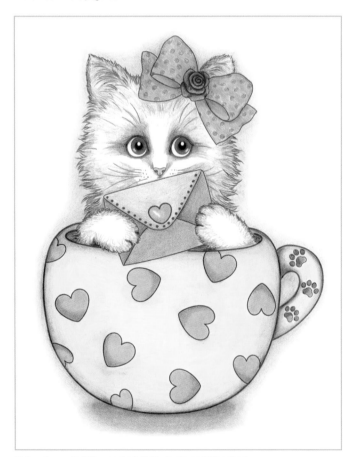

Colored pencils (Prismacolor). Color by Darla Tjelmeland.
Full of Love, page 71.

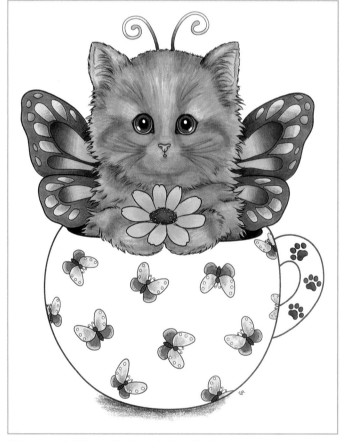

Colored pencils (Prismacolor). Color by Llara Pazdan.
Cup of Spring, page 73.

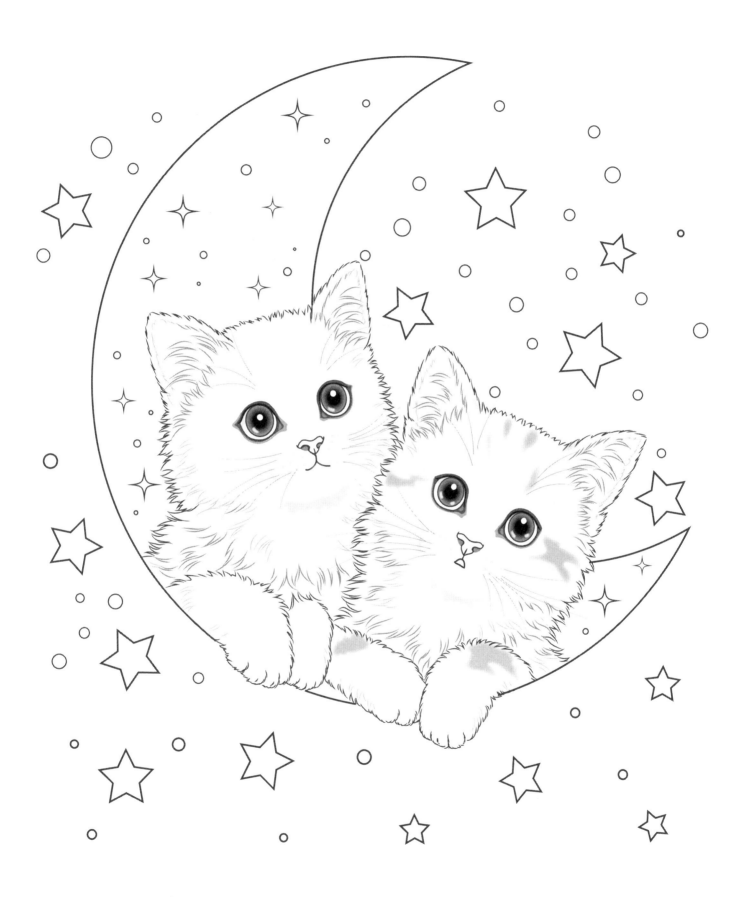

17

I think we dream so we don't
have to be apart so long. If we're
in each other's dreams, we can
play together all night.

—Bill Watterson, *Calvin & Hobbes*

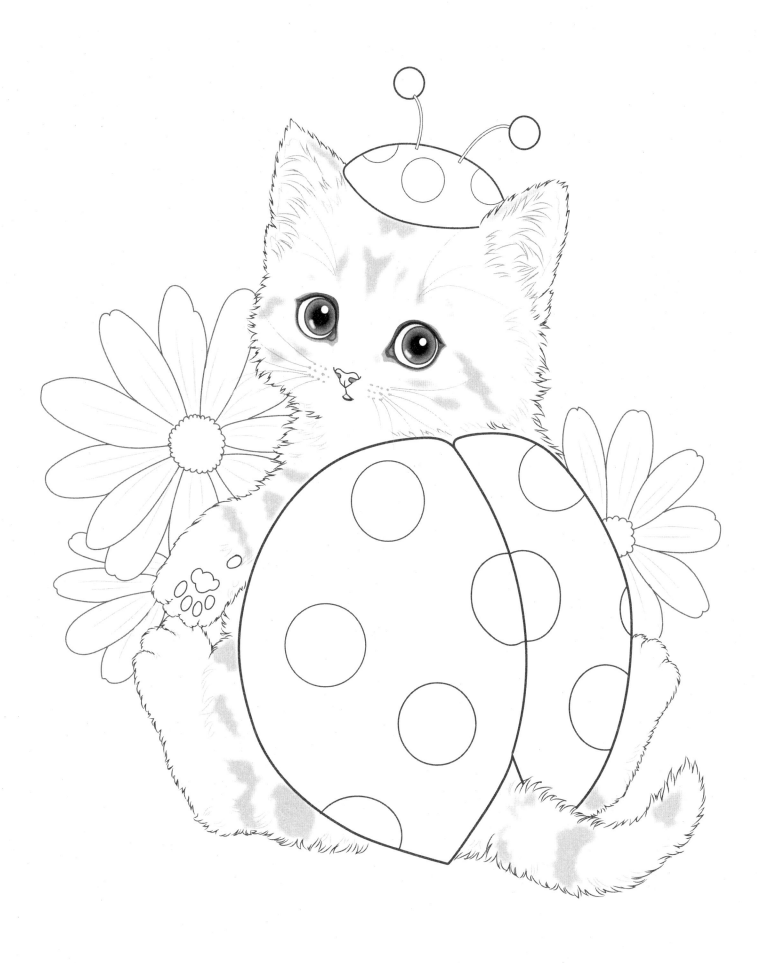

19

The ideal of calm exists
in a sitting cat.

–Jules Renard

Kitty in Red

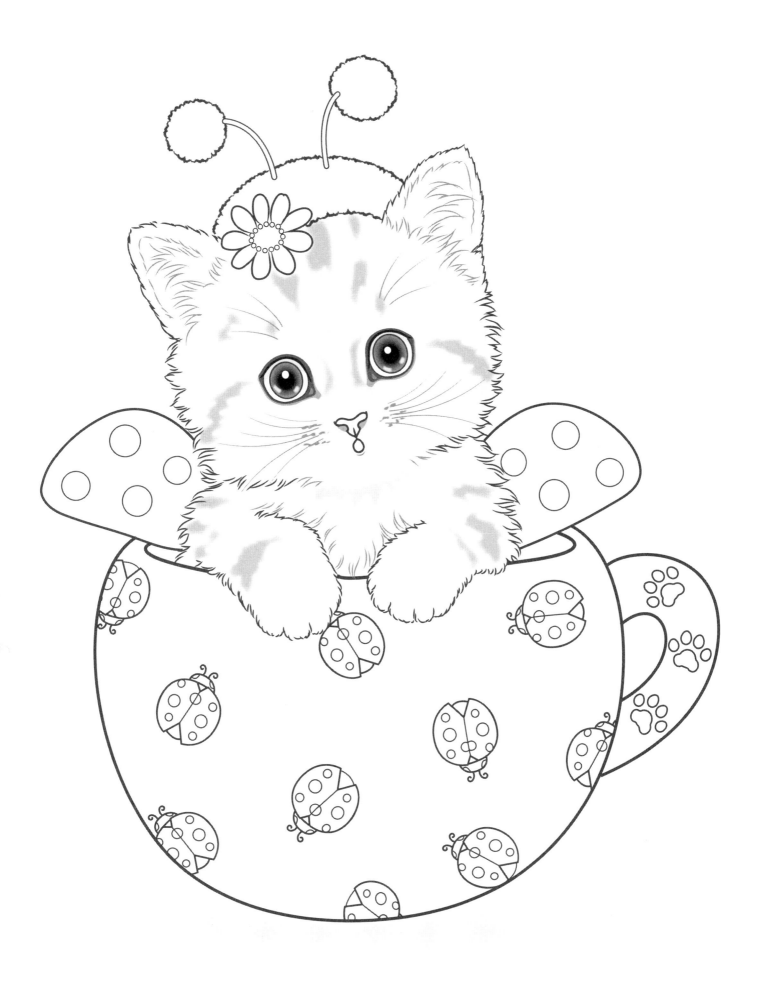

With a butterfly kiss and a
ladybug hug, sleep tight little
one like a bug in a rug.

–Unknown

Ladybug

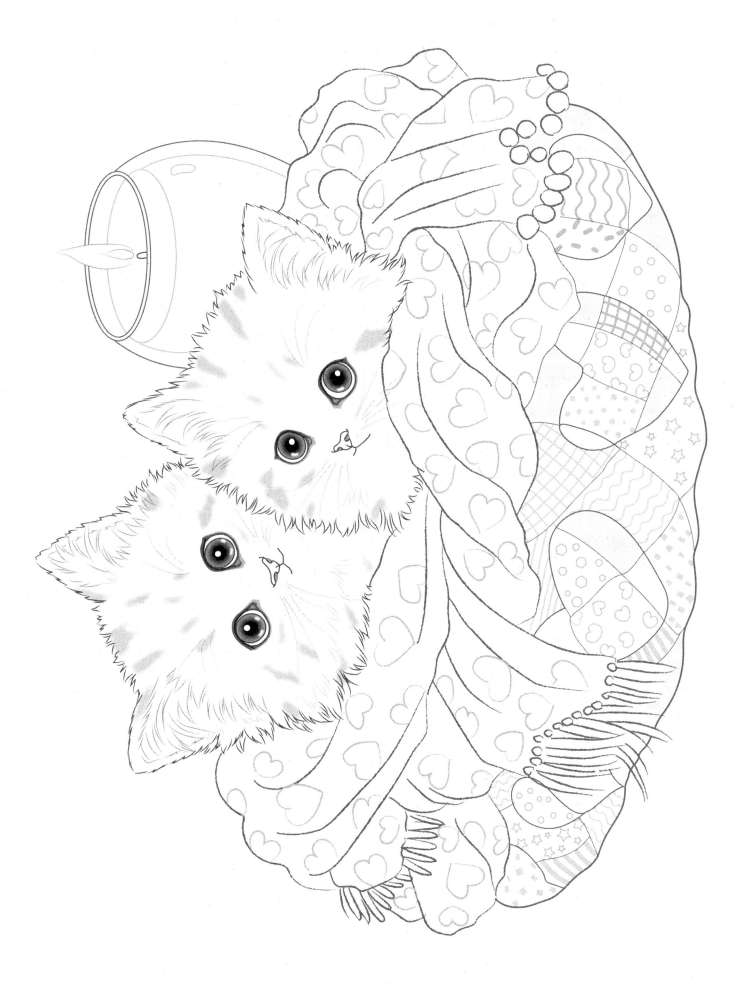

23

A cat improves the garden wall in sunshine and the hearth in foul weather.

—Judith Merkle Riley

Cozy Kitties

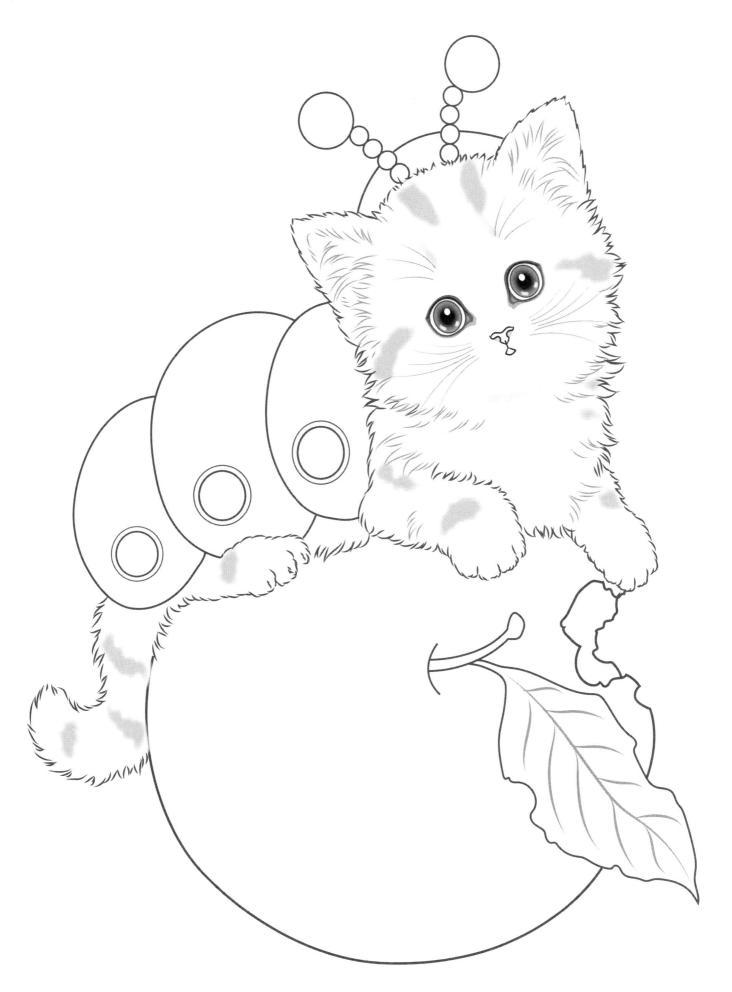

The smallest feline is a masterpiece.

−Leonardo da Vinci

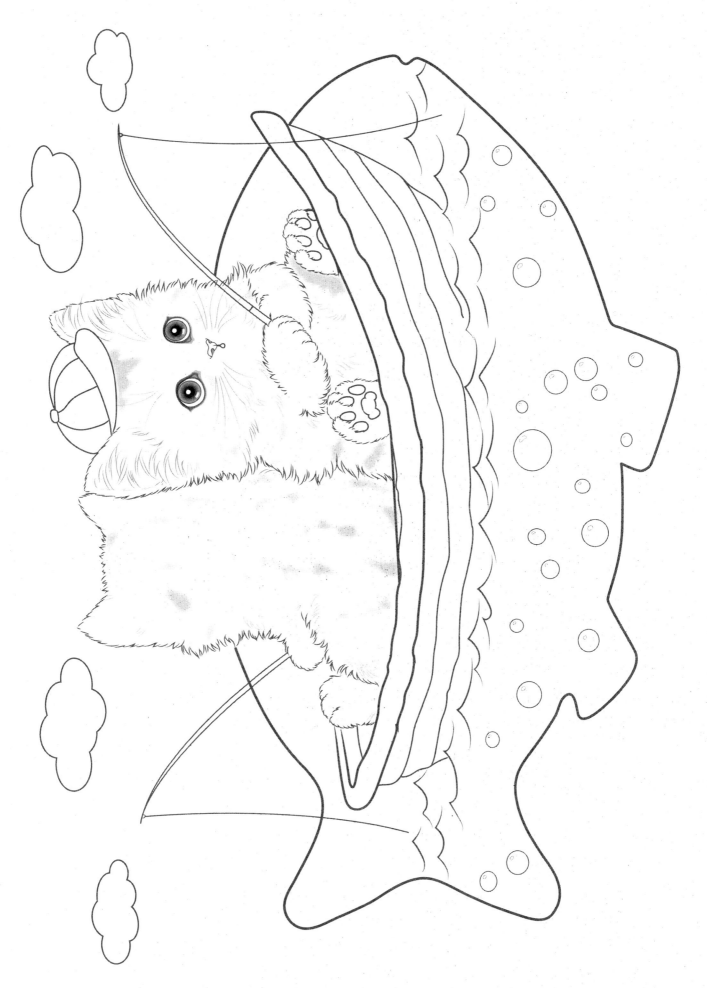

27

Nothing makes a fish bigger
than almost being caught.

–Unknown

Fishing Buddies

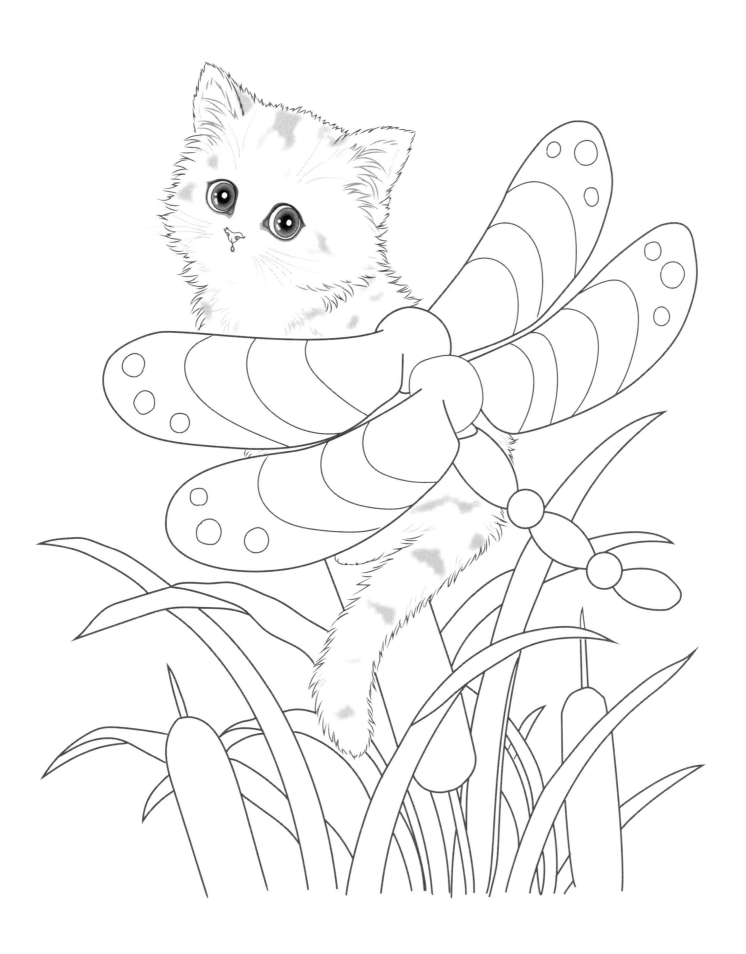

I am the dragonfly rising on the wings of unlocked dreams on the verge of magical things.

—Aimee Stewart

Winged Wonder

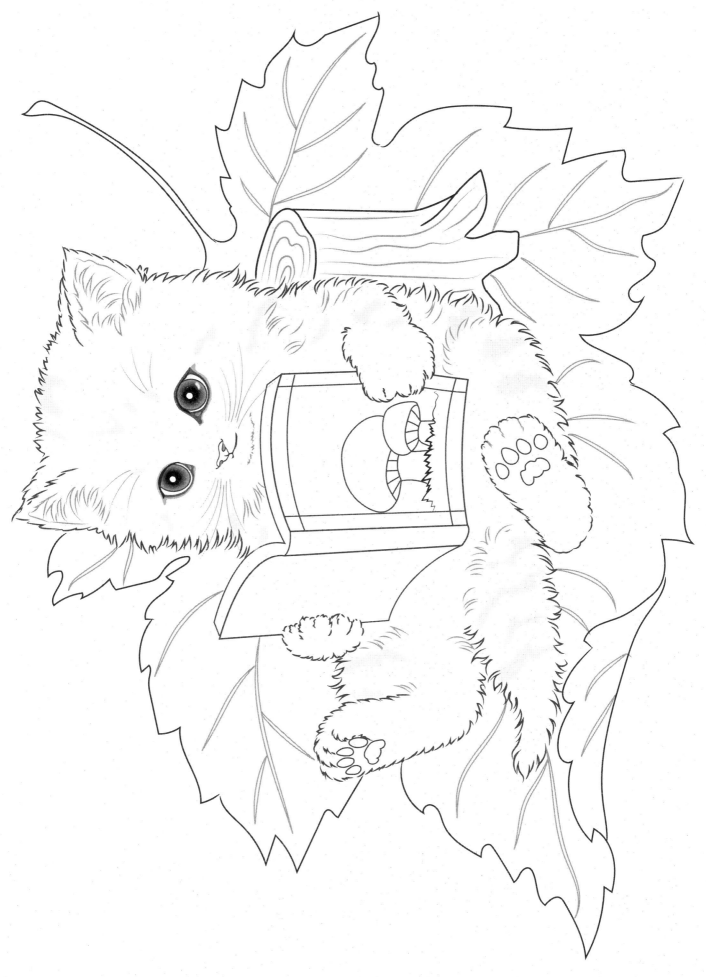

You can find magic
wherever you look.
Sit back and relax,
all you need is a book.

–Dr. Seuss

A Good Book

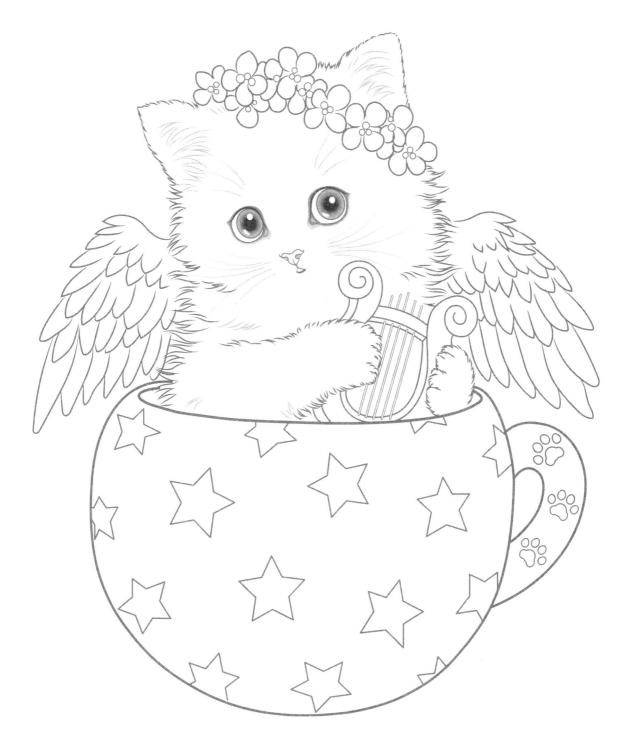

Super pale tints of colors create a
gorgeous, soft feel.

Kittens are angels with whiskers.

—Terri Guillemets

Angelic Feline

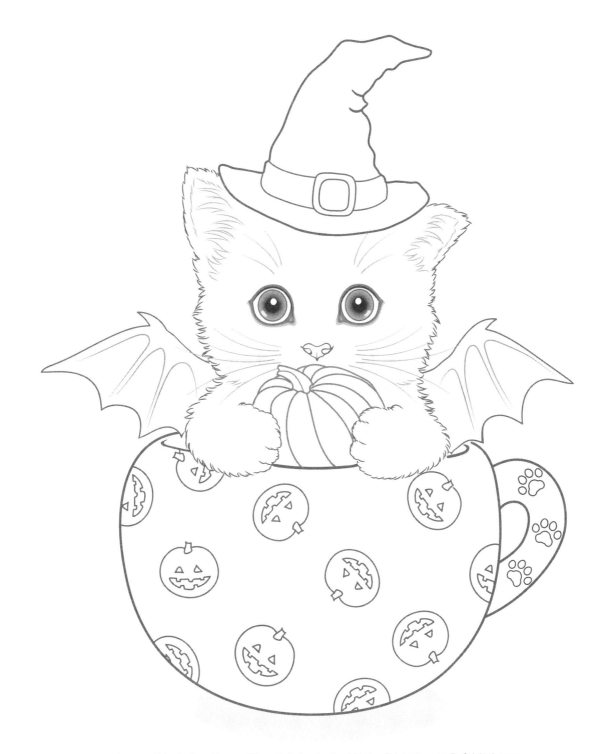

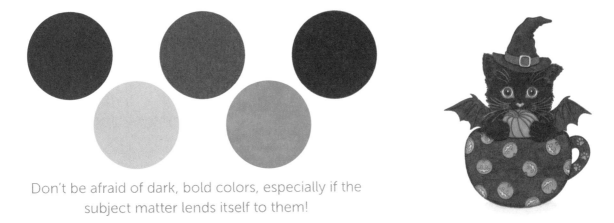

Don't be afraid of dark, bold colors, especially if the
subject matter lends itself to them!

What greater gift than
the love of a cat?

—Charles Dickens

Boo Kitty

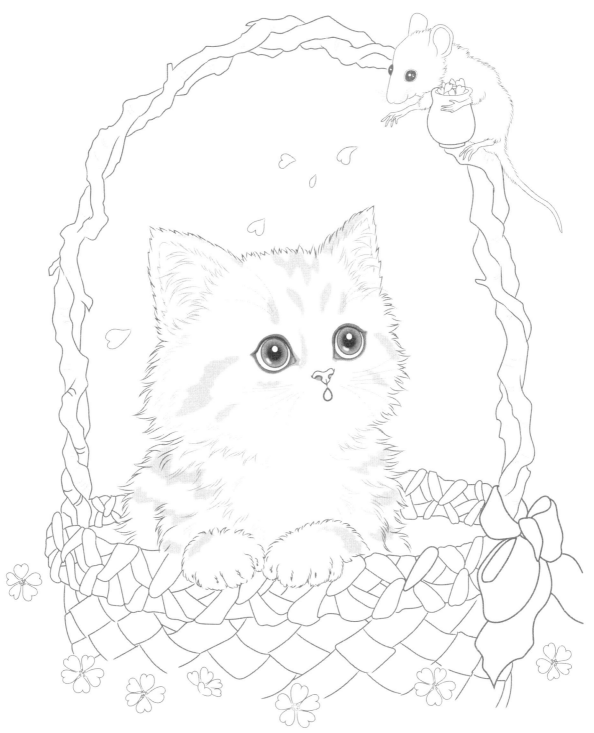

© Kayomi Harai • From *Teacup Kittens Coloring Book* • © Design Originals, *www.D-Originals.com*

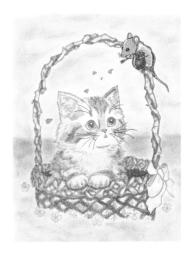

Create a physical scene that's not present in the black and white art by simply using blue for a sky and green for land.

The cat has too much spirit
to have no heart.

—Ernest Menaul

A New Friend

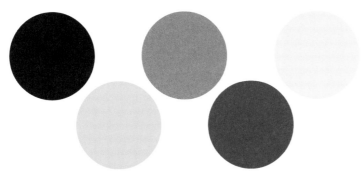

Remember, black is a color option too!

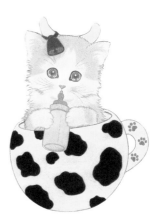

Before a cat will condescend
To treat you as a trusted friend,
Some little token of esteem
Is needed, like a dish of cream.

–T. S. Eliot

Cup o' Cat

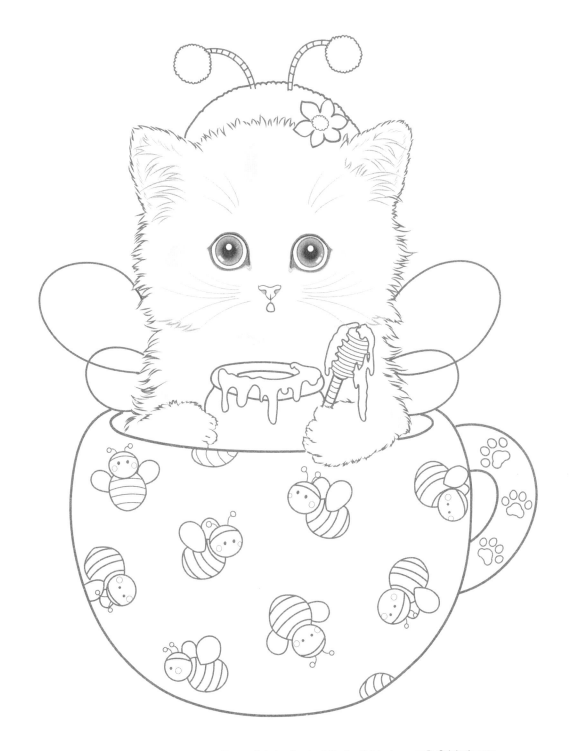

A nice olive green goes well with warm oranges and golds, providing contrast without too much excitement.

Tart words make no friends; a spoonful
of honey will catch more flies than
a gallon of vinegar.

—Benjamin Franklin

Sweetness

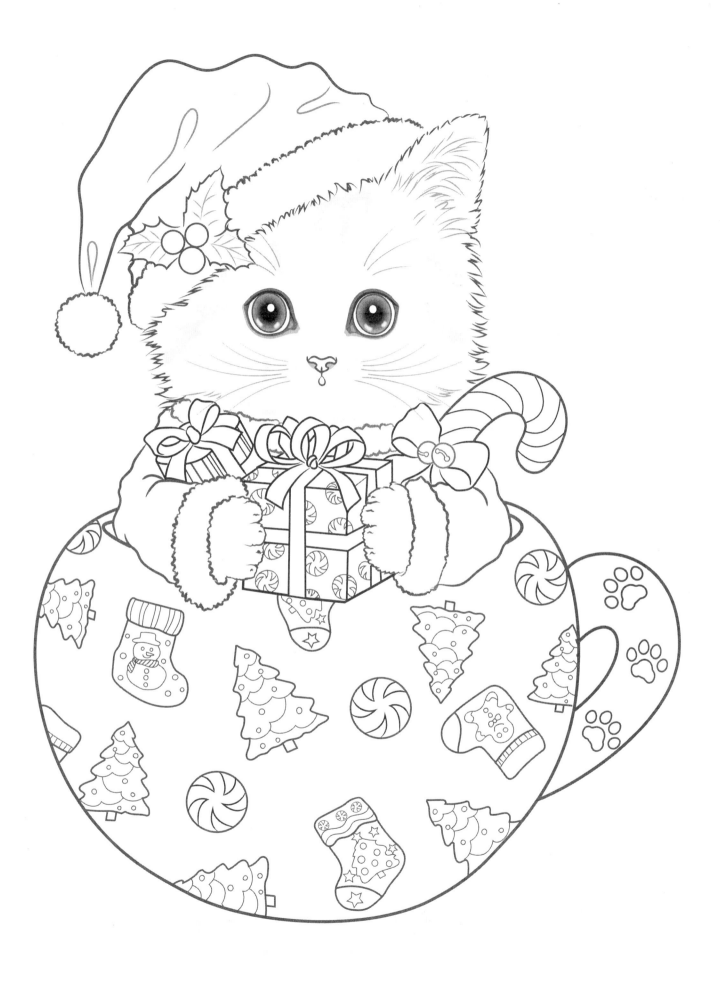

Christmas is not as much about
opening our presents as
opening our hearts.

—Janice Maeditere

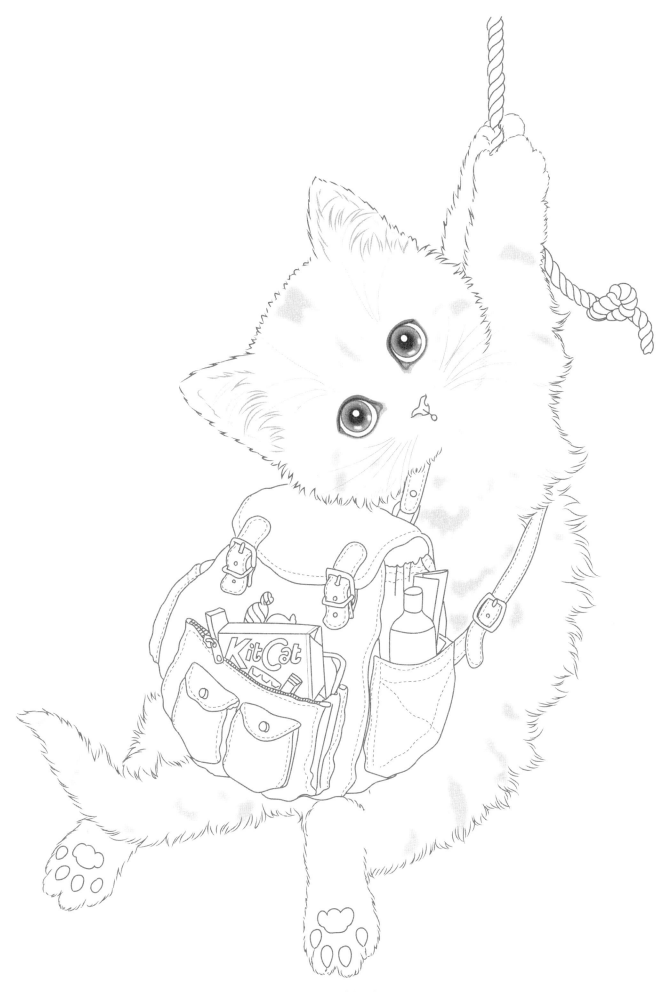

There is no more intrepid
explorer than a kitten.

—Jules Champfleury

Adventure!

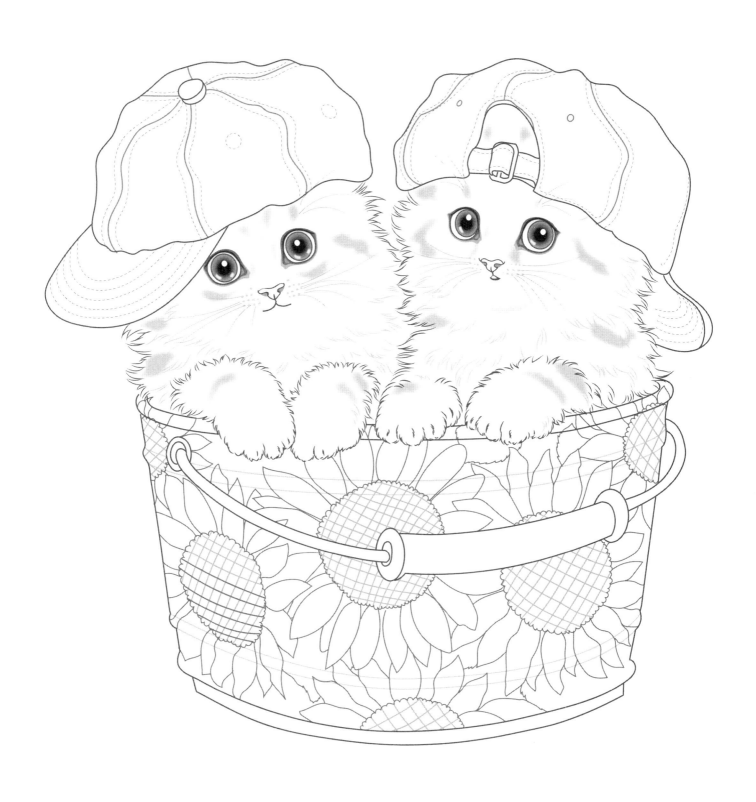

A friend is someone
who knows all about you
and still loves you.

–Elbert Hubbard

Pals in a Pail

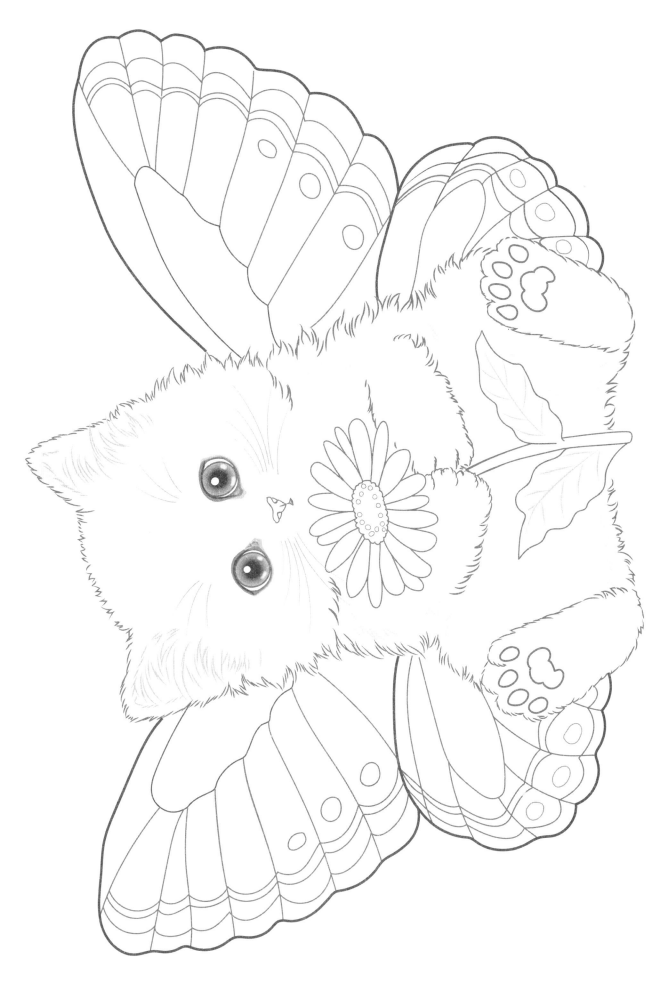

May the wings of the
butterfly kiss the sun
And find your
shoulder to light on,
To bring you luck,
happiness, and riches
Today, tomorrow, and beyond.

—Irish blessing

A Flower for You

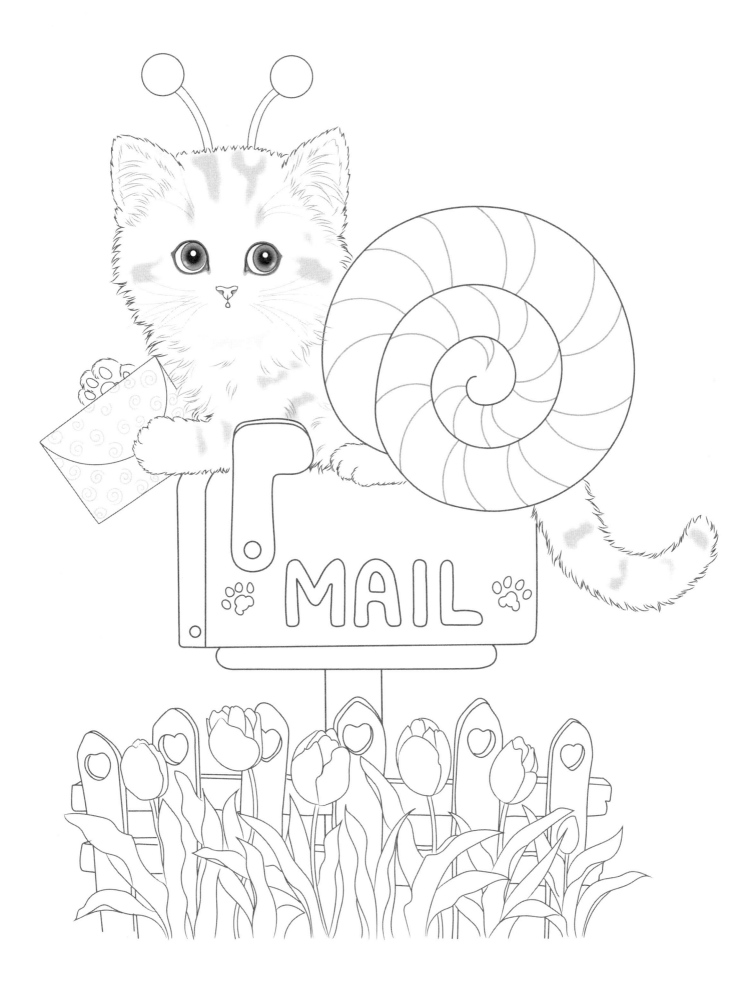

51

To send a letter is a good way
to go somewhere without moving
anything but your heart.

—Phyllis Theroux

Special Delivery

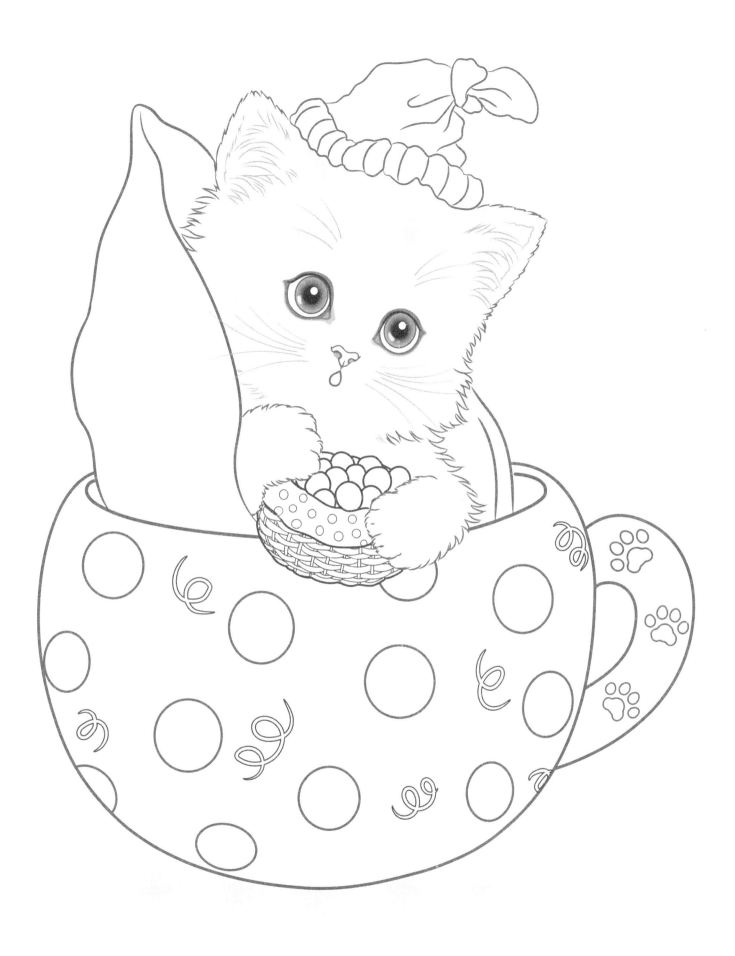

There are few things in life
more heartwarming than
to be welcomed by a cat.

–Tay Hohoff

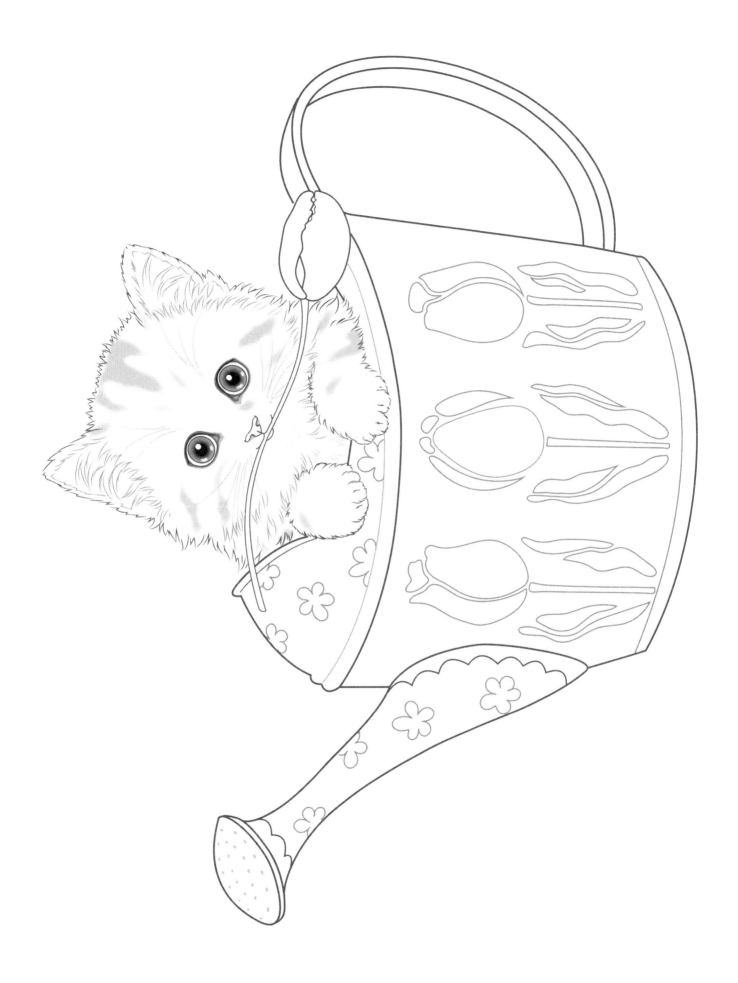

"Meow" is like "Aloha"—
it can mean anything.

—Hank Ketchum

Garden Surprise

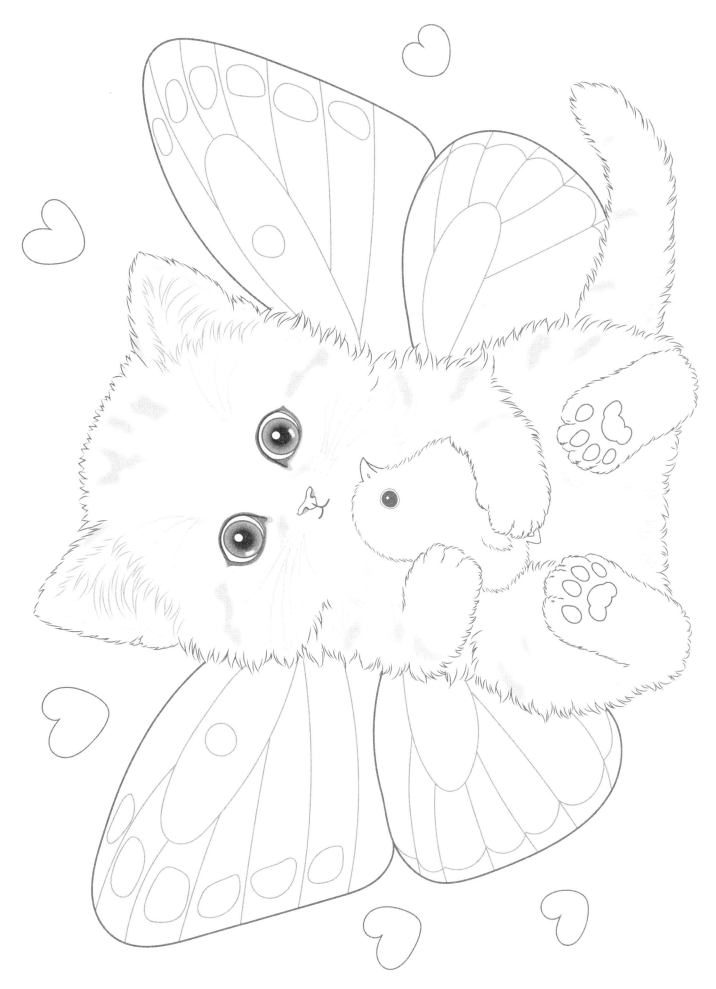

57

Animals are such agreeable
friends—they ask no questions,
they pass no criticisms.

—George Eliot

It is impossible to keep a
straight face in the presence
of one or more kittens.

–Cynthia E. Varnado

Cats are a mysterious kind of folk.
There is more passing in their
minds than we are aware of.

—Sir Walter Scott

Full Moon

Who would believe
such pleasure from
a wee ball o' fur?

—Irish saying

Froggy

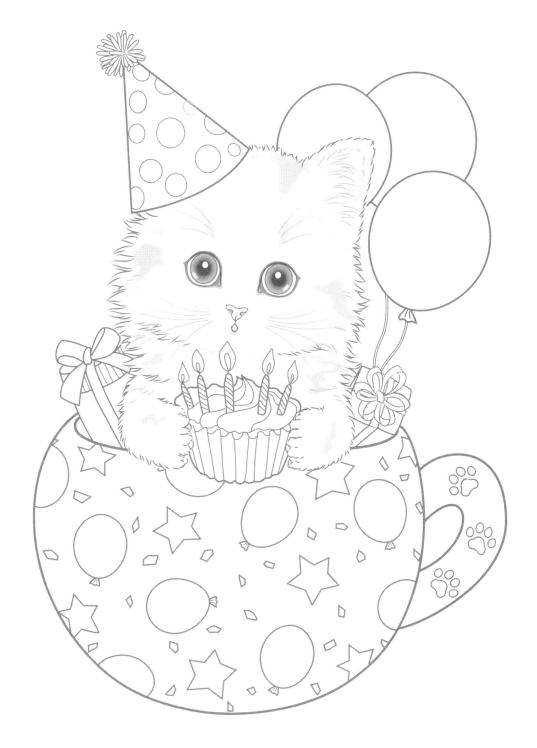

Complementary pink and green provide strong contrast, and pops of yellow add some brightness.

Time spent with a cat is never wasted.

—May Sarton

Make Your Wish

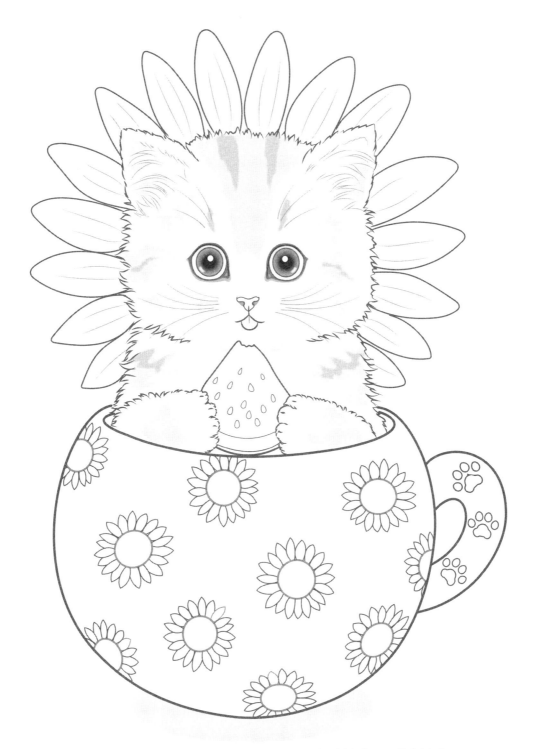

© Kayomi Harai • From *Teacup Kittens Coloring Book* • © Design Originals, www.D-Originals.com

Don't forget about white space—you don't have to color every single part of a coloring design!

Wherever you go, no matter
what the weather, always bring
your own sunshine.

—Anthony D'Angelo

Summertime Fun

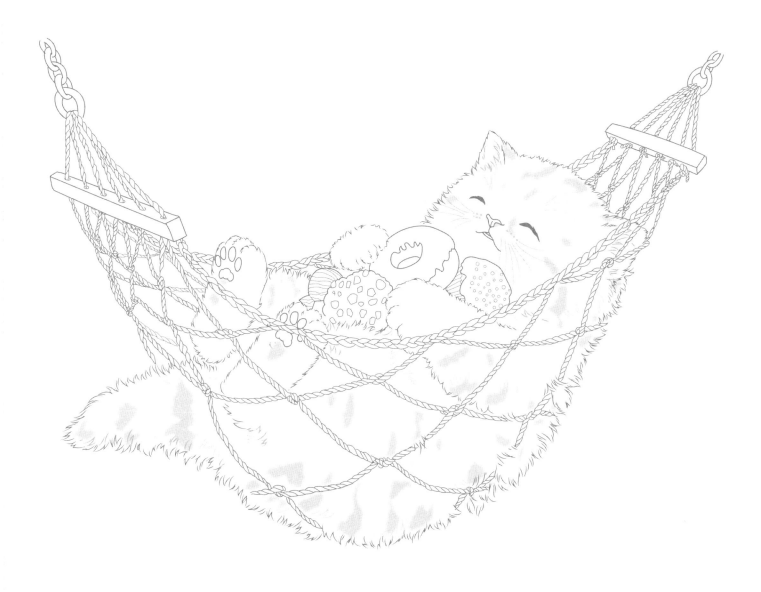

Gray may seem like a boring color, but how cute
is a gray kitten? Mix in some bright colors like
the ones used in the donuts.

Learn from yesterday,
live for today,
look to tomorrow,
rest this afternoon.

—Charles M. Schulz,
Charlie Brown's Little Book of Wisdom

Happy Hammock

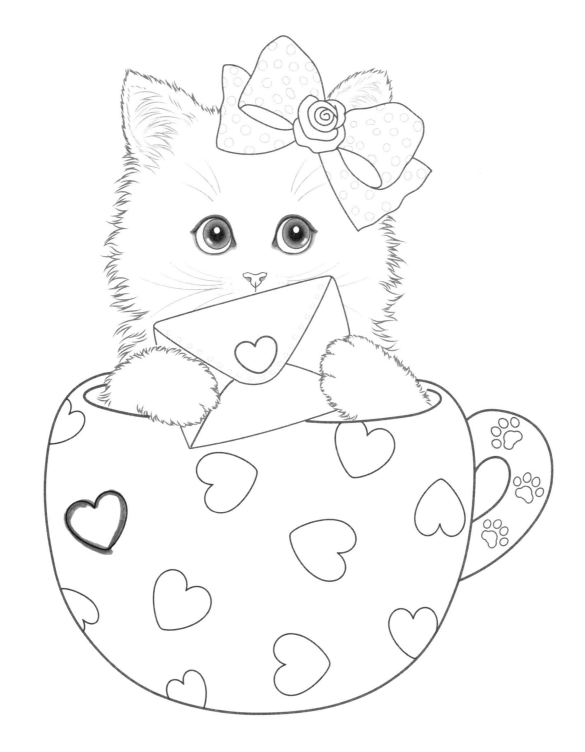

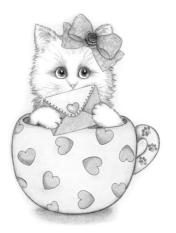

Try adding a halo of color around the entire kitten and teacup, as done with the pale blue here.

People who love cats
have some of the
biggest hearts around.

−Susan Easterly

Full of Love

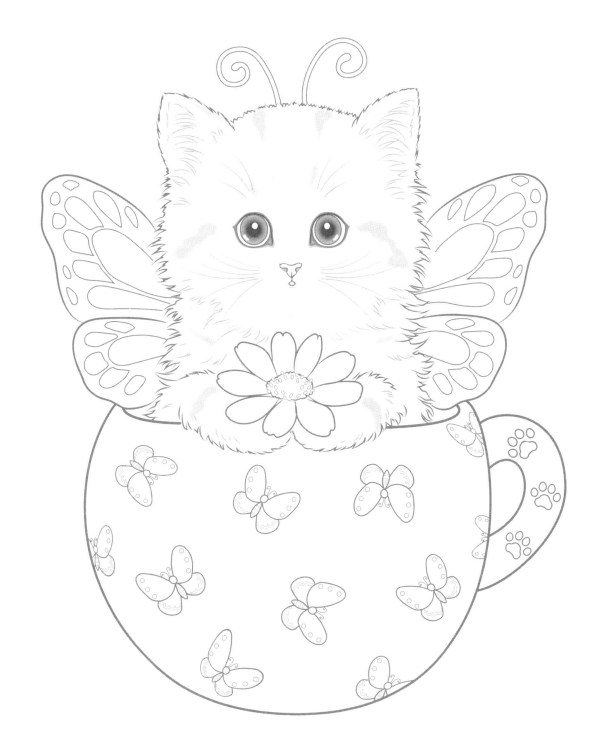

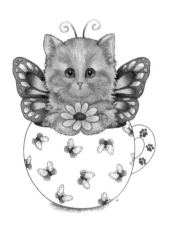

Choose three related colors, like pink, purple,
and blue-violet, for a consistent but still
interesting color scheme.

It's a beautiful day.
Don't let it get away.

–U2, *Beautiful Day*

Cup of Spring

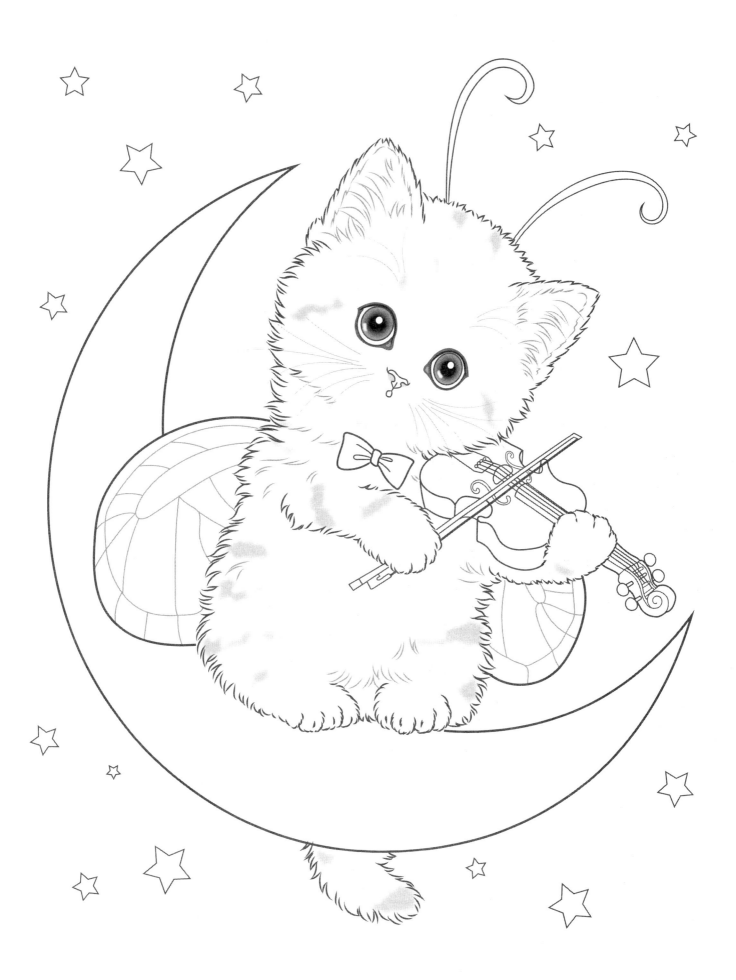

There are two means of refuge from the miseries of life: music and cats.

—Albert Schweitzer